# How to use
# Water-Soluble
# Pencils

## and other aquarelle media

WENDY JELBERT

SEARCH PRESS

First published in Great Britain 1994

Search Press Limited,
Wellwood, North Farm Road,
Tunbridge Wells, Kent TN2 3DR

Reprinted 1995, 1996, 1998, 2000, 2001

ISBN 0 85532 771 5

Printed in Spain by Elkar S. Coop. 48180 Loiu (Bizkaia)

**Note :** The names of colours in this book are approxi-
mate ones. Each manufacturer's product are slightly
different in colour, and if precise shade is important,
ask if you can test before purchase.

# Contents

Jelbert

# Introduction

Water-soluble (or aquarelle) pencils and pastels, when used with inventive and imaginative techniques, can produce a wide range of exciting textures, patterns and effects. They really do deserve to be treated as a medium in their own right, rather than just as a substitute for other materials.

The technology involved in the manufacture of water-based media is so highly advanced that permanence is now virtually guaranteed, and more and more rich, varied colours, rivalling those of paints, are now available at quite competitive prices. As with most modern materials, these pencils and pastels can be bought in different sizes of boxes and packets, or, if you wish, just singly in the colours you prefer.

There are many makes on the market now, each manufacturer offering different styles and qualities, such as harder or softer leads, a dense or waxy pigment, or differently shaped casings for easier handling. It may, therefore, be a good idea to try out different makes before purchasing a whole set.

They are easily portable and are excellent for detailed work on carefully observed studies of flowers or animals *in situ*, without the pressures and problems of quick-drying washes!

Alternatively, if you are a landscape painter, you can block in larger areas using water and these water-based media, or make accurate colour sketches on the spot, to be worked up in the studio later on. Some of the most exciting pictures

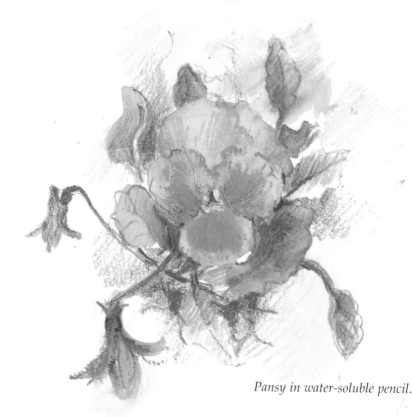

*Pansy in water-soluble pencil.*

4

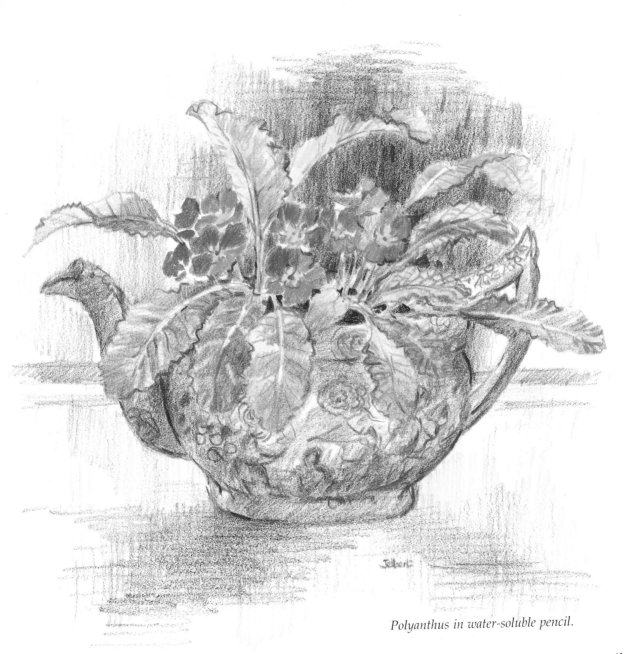

*Polyanthus in water-soluble pencil.*

I have seen have been made by combining paint with these drawing materials, or by using them with water and inks, or by using both media together.

You will need to invest some time and effort in practising with these materials; as you will discover, the more you experiment, the more will be revealed. You will probably find that water-soluble media will perform best when taken beyond conventional channels, when you exploit their free-flowing colour qualities by using water with a brush or a spray, rather than relying on them purely as drawing instruments.

If you make mistakes when using pencils, these can be erased with a putty eraser only when in the form of a drawing, because once you add the water, the paper absorbs the pigment. You can use this method to gain highlights or to diffuse hard edges.

Most papers, such as cartridge or thin sketch-book paper, can be used, especially when you are not working with water. Once wetted, a thin paper will wrinkle and be in danger of being punctured, especially by a hard pencil, so my personal choice would be a 190gsm (90lb), or 300gsm (140lb) watercolour Not surface.

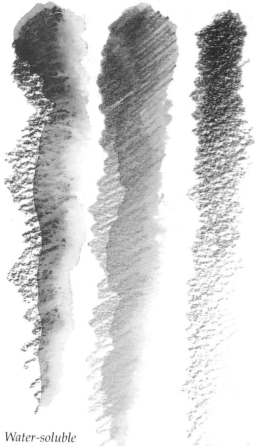

# Sketching and drawing

In making a drawing or study from any object, the mind may be influenced by two factors: first, the endeavour to produce an exact likeness, resembling a photograph; second, the desire to make a judicious selection, and to put down your own personal poetic thoughts on the matter on to paper. Equally, the recording of facts and details is extremely important for future reference, as are the feelings the subject aroused in the first place. Both these requirements can sometimes conflict in the same drawing. For this reason, I often draw and sketch the subject several times, stating different things about it. First of all, I may

*1. Water-soluble pencil.*

*2. Graphite pencil.*

*3. Water-soluble pastel.*

*Harbour scene in water-soluble pencil.*

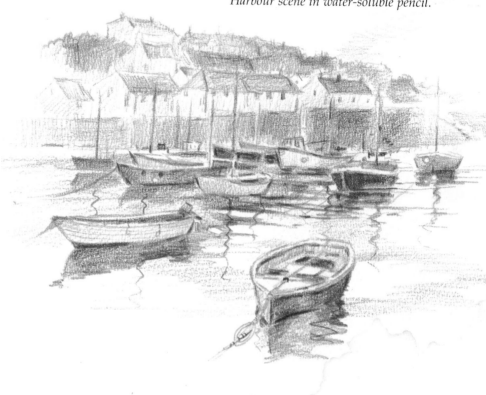

make a quick sketch capturing a brief moment or mood, and then I may take a photograph recording all the details (but in a sterile form!). Finally, if there is time, I will finish off with a detailed drawing in tone and texture.

Here I have sketched and drawn several subjects in the various media we will be exploring. Water-soluble pencils and aquarelle graphite pencils are ideal for the artist when speed and convenience are essential. The various makes of graphite pencils are manufactured and available in small sets, or they can be bought individually. Easy to handle and light to carry, they can be used for sketching in many ways to gather important reference work, and can therefore be used with ease in your sketch-book. You can vary from a loose scribble, washed gently with water, thus dissolving it into soft washes, to bold vigorous statements which, when overlaid with additional layers of either dry or wetted pencils or pastels, can give excellent sketches or drawing impressions.

These samples are of the three media I use constantly.

(1) The aquarelle (water-soluble) pencil, used dry and with water (burnt sienna)

(2) The graphite pencil (3B)

(3) The water-soluble pastel, used dry with varying pressures depicting tonal changes (it may also be wetted).

*Study in graphite pencil.*

7

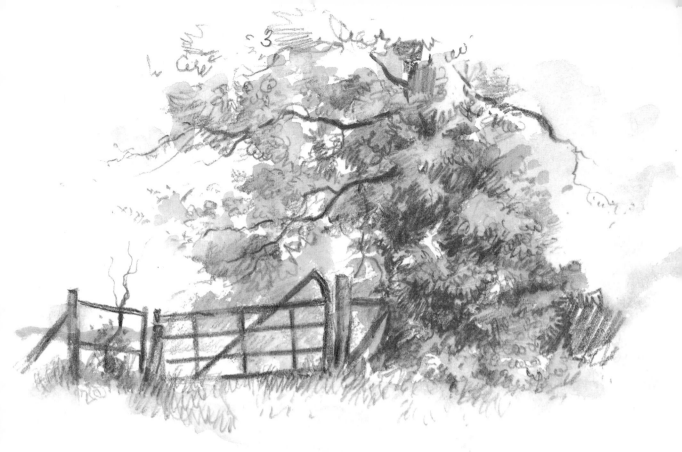

*The field gate – a sketch in water-soluble pencil.*

In this sketch of the field gate, I drew in the main features and then, using hatched and textural markings, made impressions of the foliage and grasses, strengthening them with tones of the shadowed area before washing over the whole image with a soft brush and clean water. This diffused the hard edges and softened the darker tones.

When the paint was completely dry, I reinstated some of the more pronounced branches and details on the gate. I do like these mellow browns, which give such lovely earthy tones; and the soft browns and light reds, reminiscent of those used by the Old Masters, are excellent.

When using the pencils in a more traditional style, I am able to ring the changes by drawing with the dry pencil, as in the harbour scene on page 6, and then adding another dimension by adding water to the dry burnt-sienna image, such as this portrait of my student Phyllis. I used the aquarelle pastel with a quick and varied rugged line.

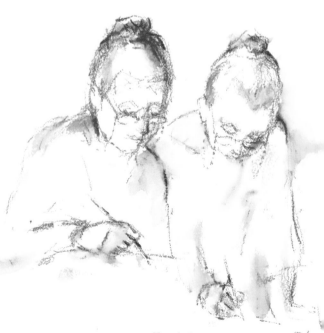

*Sketch in water-soluble pastel.*

The prelude to every successful painting is some kind of preliminary drawing. In this cat study, which later on I worked into a painting, I endeavoured to jot down the expressive movements that animals make and which are almost impossible to capture when you are trying to get them down at speed. They really do seem to sense that they are being sketched, even when they appear to be fast asleep, and move just before you can complete the pose. The saying that you do not know a subject until you draw it is quite true.

Here, in these three quick studies, I used burnt sienna, violet and Vandyke brown pastels and pencils, both wet and dry, to get a varied quick and rugged line. I wet them only to give a brief tonal statement. The pastels also give a lovely 'flow' to a drawing, and an expressively lively line can be achieved by varying the pressure and choosing to have a wet or a dry finish.

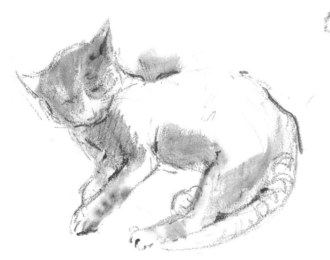

*Cat sketches in water-soluble pastels and pencils.*

# Trying out water-soluble pencils

Surprisingly, these pencils are often regarded as instruments for children alone. Through my years of experience as an art teacher, and as a demonstrator for several art manufacturers, I have discovered that they are a great asset to any painter (whether professional or amateur), designer, or illustrator. They offer great spontaneity and freedom of expression, whether used for drawing or actually carrying the colour.

They can be used in an uncomplicated way, just as if you were using an ordinary graphite pencil, or can be mixed in with plain pencil. If colour is the main purpose, they may be used to indicate colour, either with feathery, delicate marks, or with watery washes encouraged from the pencil-markings themselves by using a simple pot-plant sprayer or a brush loaded with clean water.

These pencils need sympathetic handling, so their many qualities and great potential can be exploited to the full. This collection of exercises will help you on your way!

From left to right:

(a) Try some scribbles of pencil, with a wash of clear water to dissolve the markings.

(b) The same exercise as above but with a hatching of another colour.

(c) The same again, but with a third colour added.

(d) Draw a graded square of dry-pencil work, altering the pressure used and therefore varying the amount of pencil deposited on the paper, and then wet half the surface.

(e) Make some small pencil stab marks, altering the texturing, and spotting in another colour. Try wetting half the paper beforehand, and watch the markings dissolve.

(f) Set three colours up in strips and try wetting them and watching the mixtures of a fourth colour covering the lighter shade.

(g) Holding three colours in the same hand at once, dot at different angles, spotting the surface, then wet over the top of the marks.

(h) Repeat as above, but making little circles.

(i) Gather a brush full of colour directly from the pencil-point, and discover how it resembles a true watercolour wash.

(j) Experiment with the use of the pencil by rolling it and then dragging it over a dry and wetted surface.

(k) Repeat as above, but using more colours.

(l) With three pencils bunched together, doodle and wander around the paper in a dry manner.

(m) Depositing a thick layer of pencil-work in the centre of your square, tease out the colour with a wetted brush.

(n) Repeat as above, but using two colours and easing the colour together in the centre.

(o) Arrange three blocks of colour in your square, dropping on a little clear water and rocking your paper slowly to reveal the way all the colours blend and fuse.

*Trying out water-soluble pencils.*

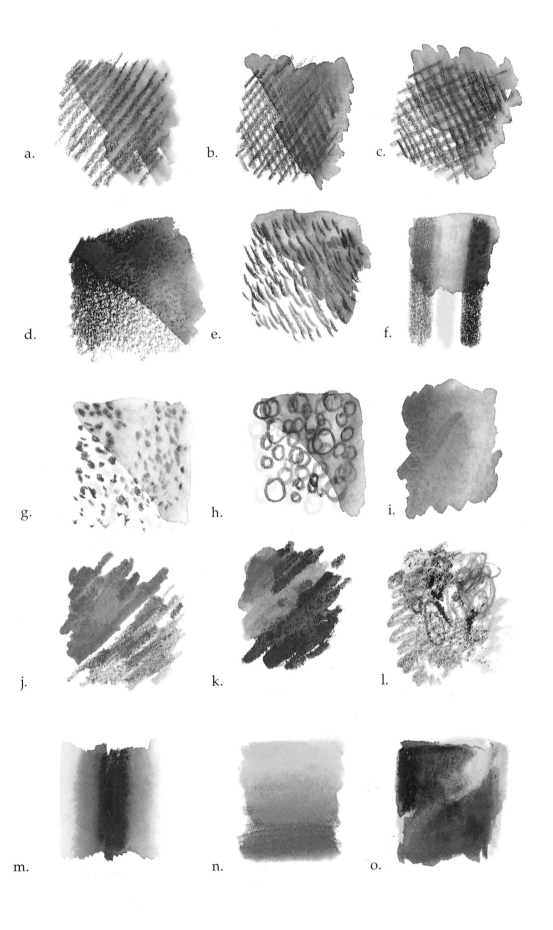

a.

b.

c.

d.

e.

f.

g.

h.

i.

j.

k.

l.

m.

n.

o.

# Trying out water-soluble pastels

These solid sticks of watercolour look like oil pastels. The formal methods of drawing are heightened and noticeably bolder when using this medium. A strong sense of the subject's colour is conveyed, whether the pastels are used wetted or dry; the intensity of colour that emerges when water has been applied to them adds great vitality and richness. However, if a gentler, softer approach is needed, a light touch, combined with a selection of the softer colours, is equally appealing. These pastels are a good servant to any painter and an obvious advantage in creating that elusive 'sparkle' in your work!

The following methods may help you to discover a new friend!

From left to right:

(a) Try out one colour, blocking it into a square, and then wetting it. Note how much water you may need for various effects.

(b) Place two colours together and blend part of them together.

(c) Apply small lines of colour side by side and then wash over part of the design, watching how the colours slowly dissolve and merge.

(d) Wet the paper first, then apply the dry pastels to the surface.

(e) Gently blend two dry pastel colours together.

(f) Wet the surface, and add small dustings of the dry pastel (keep the shavings when you are sharpening the pastels!).

(g) Try covering a square with an equal wash of colour. (This is not as easy as it looks!)

(h) Wet the end of your pastel and take a little off with your paintbrush, applying it to your paper like a traditional watercolour wash.

(i) Try out an assortment of dry markings, using each edge and the sides of the pastel. I like to break certain colours to 2.5cm (1in) lengths to obtain maximum results.

(j) Cross-hatch a set of colours, then use a little water to diffuse the hard edges. Note how much water is needed for certain effects and which colours need more coaxing to dissolve than others.

(k) Using the same method as above, try out different patterns, such as this dotty effect.

(l) Using various dry colours, experiment with the strength of their 'covering power' and glazing effects.

*Trying out water-soluble pastels.*

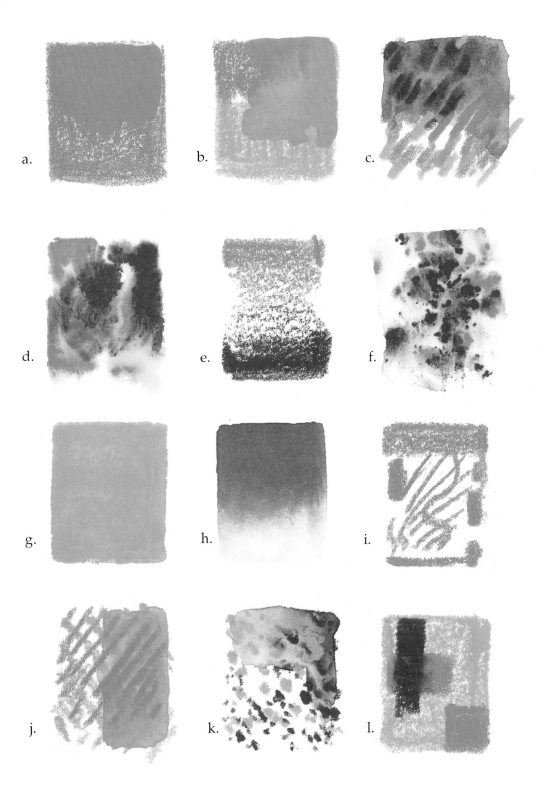

a.

b.

c.

d.

e.

f.

g.

h.

i.

j.

k.

l.

13

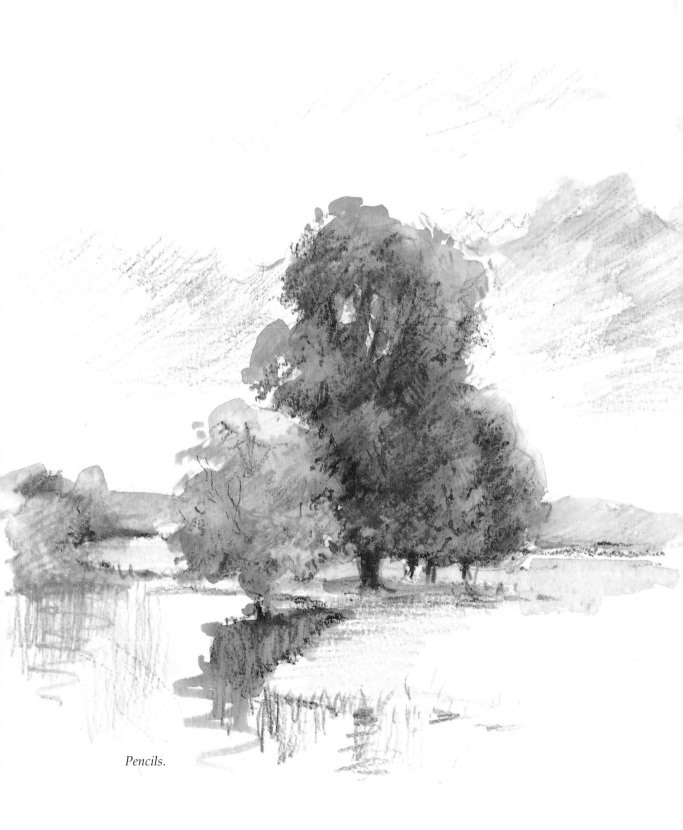

*Pencils.*

14

# Comparing pencils and pastels

There is no better way of approaching a subject than actually drawing it!

This tree study is from my sketchbook: I thought it ideal for illustrating both pencils and pastels.

First of all, neither of them is 'better' than the other! Each has its own beauty and solves its own problems.

**Pencils**  A pencil study will always look like a drawing except when you are using the colour straight from the tip with a brush. Here I have used both methods.

Painting in the contrasting tree shapes and letting the paper dry, I cross-hatched greens and ochres, and blues and violets, creating the massed forms of various leaves. Skies are generally subtle greys and blues, so I drew in pale-blue lines with tiny accents of burnt sienna, sweeping from the distance to a cloud formation in the foreground, and then wet a small proportion of this area to give depth. Finally, I drew in details of the banks and reflections and washed over them.

**Pastels**  Working with pastels gives a more rugged effect, and in the picture below I have used watercolour washes from the tips of the pastels for the distance, the sky and the water. I pulled some of the bank colour into the water.

All the contrasting tree shapes were individually blocked in with yellow, blue and brown, and then washed over, taking the colours down into the reflections. When the paper was completely dry, I drew some dry pastel across the tree, for leaves, and drew in branches at intervals.

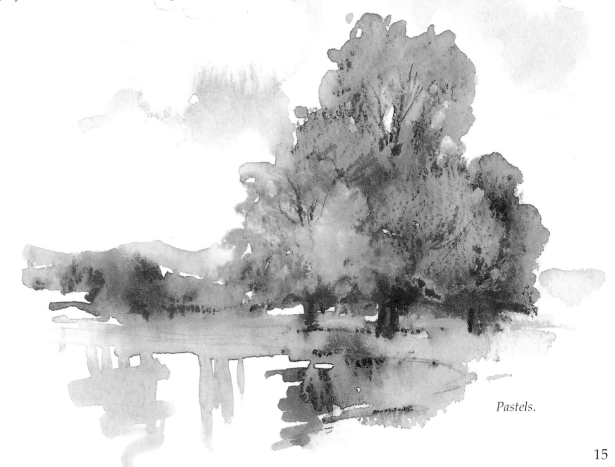

*Pastels.*

# Mixing pencils, pastels, and other media together

When you have experimented with both these exciting aquarelle media and have become accustomed to their characteristics, it is time to go even further. There are endless combinations and additions, some of which are mentioned in this section. Many are yet to be discovered, and on this journey of exploration you will surely stumble on several of them yourself, widening and improving your artistic language.

There is no reason why any one of these media cannot be combined with watercolours, mixed with another water-soluble medium, used with masking fluid, or used in combination with various inks. Scoring the paper, either before or after the colour has been applied (when more colour is added the image is emphasised), or adding salts to the washes can also give interesting textural results.

I have again set out some suggestions for you to try.

From left to right:

(a) Apply masking fluid using a drawing pen. When it is thoroughly dry, apply washes from the tips of either the pencils or the pastels. When the washes are dry, rub off the masking fluid to reveal the white paper which has been protected by the fluid.

(b) This shows layers of wet colour from the pastels and wetted-pencil work applied on top. By trying various colours, you will find that some cover better than others.

(c) Try out the same exercise as above, but using dry colours in assorted strokes.

(d) Try mixtures of wet and dry pencil and pastel work, combined with ink, which is used to define the edges.

(e) Use larger dry areas of pencil to cover pastel work.

(f) Try developing an assortment of dry markings with the pencils and pastels.

(g) Drop some salt into a watercolour wash formed by either medium. Allow this to dry, and then brush off briskly to reveal marbled or starred effects.

(h) Here, watercolours are used as a base and then overlaid with pastel and pencil. Successive applications can be used for depth and texturing.

*Mixing pastels, pencils and other media together.*

a.

b.

c.

d.

e.

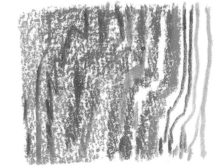

f.

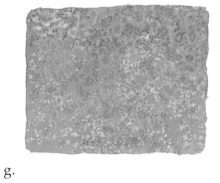

g.

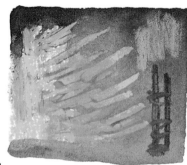

h.

# Trying out various methods and styles

## An assortment of sweets

In this fun section, I have used sweets as the basis for putting some of the previous exercises into practice. The key to getting good consistent results is knowing what to expect.

### Materials

*Aquarelle pastels and pencils in various colours.*
*Brushes and watercolour paper.*
*Ink and pen, or steel-nibbed pen.*
*Masking fluid and drawing pen.*
*Pot-plant sprayer.*
*Watercolours.*

**The yellow toffee** Dry-pencil work in bright yellow was cross-hatched in delicate strokes in the main area. For the deeper shades, I used additional layers in ochre, burnt sienna, and dark browns. This gentle use of layering of colours is an effective way of weaving rich colour and depth. By a change of grip and the use of differing amounts of pressure you can experiment with the broad range of effects. Light pressure creates gentle tones and allows more pencil to be added. Pressing harder adds a dense coating that will not accept many additional layers!

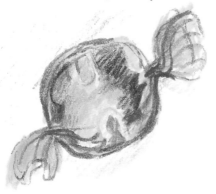

*The yellow toffee.*

**The green chocolate** I took a bright green wash from the pencil-tip with a soft brush and allowed it to dry. Then I added layers of pure dry colour, rather as I did in the above exercise, and hatched in some fine lines, allowing the initial coats to 'glow' through. Finally, I just suggested a shadow in light-blue and grey pencil-work.

*The green chocolate .*

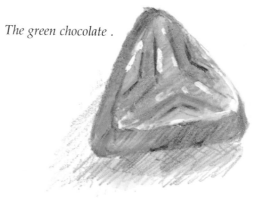

**The blue sweet** A wash of light bright-blue pastel was painted over the whole drawing and background. While it was still wet, I blocked in the small abstract shapes in different blues, capturing the shiny surface design. I left small slivers of untouched paper to serve as highlights.

When everything was dry, I applied dry-pencil hatchings, and some ink to create the wrapping and shadow details.

*The blue sweet.*

**The red toffee** This aquarelle-pastel illustration shows that using many short sharp strokes to build up the surface is quite effective.

Here I have used markings of yellow, orange, ochre and red, hatched into the blue shadow, because these loose strokes make the subject more vibrant.

A quick drawing in blue pencil defined the sharp change of plane in the sweet's surface.

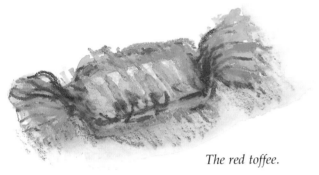

*The red toffee.*

**The round blue sweet** I sketched in the shape with blue pencil and wetted the surface of the paper. Then I dotted brown and blue pencil-shavings into this and let them fuse and merge (pastels can also be used in this way). The juxtaposition of diffused and sharp images offers an extremely attractive contrast.

The patterns on the wrapping were completed in dry-pencil drawing.

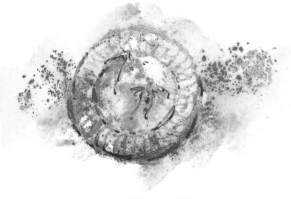

*The round blue sweet.*

**The milk chocolate** I cross-hatched and layered a variety of fine dry pencil lines in various browns over an initial undercoat of yellow-ochre watercolour, which was dry before I applied the lines.

The coloured drawing surface was then gently wetted with the small sprayer. Do take care not to 'blast' at your fragile image as it has the habit of quickly running off the page! You may need to have several goes before the results are acceptable.

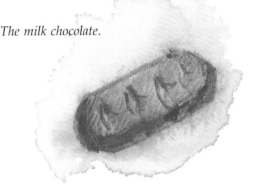

*The milk chocolate.*

**The striped sweet** I drew in the sweet and then applied the white decorative lines using masking fluid and the ruling pen. When this was dry, I placed in the yellow foundation colour with the transparency of the pencil, using a wash directly from its tip. Take care when using masking fluid with direct pencil or pastel work, as you may lift the image beneath. Here I always use the colour with a brush.

After rubbing out the dried masking fluid, I cross-hatched a few yellow and burnt-sienna lines over some of the white lines to deepen the shadows. To complete the exercise, I applied a layer of blue pastel wash to merge the colours into a flowing semi-transparent wash.

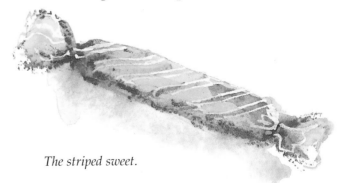

*The striped sweet.*

# Pencils and pastels: wet and dry

This was one of those gorgeous sights that really took my breath away! A rain of glowing golden racemes of flowers cascaded over these garden steps and highlighted the sun-filled beds beyond. This subject, full of contrasts, free and flowing yet detailed and structured, struck me as being ideal for the combination of drawing and painting techniques I so much like to use with these pencils and pastels.

This painting clearly demonstrates the dramatically different looks you can get with pastels: the left-hand side shows them used dry and the right-hand side with the addition of water.

I selected dark and cerulean blue, deep green, yellow, brown and deep red water-soluble pencils; orange, bright yellow, dark and light green, violet, pink, burnt sienna and bright red water-soluble pastels; a soft No. 6 watercolour brush, and watercolour paper (190gsm (90lb) Not surface), anchored to a board with masking tape.

As you can see, I sketched in the happy chaos and 'activity' of this garden scene with a blue water-soluble pencil. I had to arrange my composition into some sort of order, with not too much confusion, which meant simplifying the whole scene into shapes of colour and tone. The background had to be very dark, using close-knit lines of dark-green and blue pastel. The light area in the background was a web of cross-hatching using pink, yellow, light-green and blue pencil. I added darker accents dry, using a heavier application of dark-blue pencil. At this stage, everything was left untouched by water, as shown to the left and in the centre of the picture.

Next I drew a bright yellow pastel over the laburnum flower heads, with a quick line covering over some to create the darkening in the shadows. Then I placed in the dots of colour for the pansy heads in yellow and red. I took care to emphasise the differences betwen the array of foliage adorning the surrounding beds: the frilly cluster around the steps was drawn in using dark blue and a filling of cerulean blue, while I made the spiky grasses around the base of the wooden arch and the finger-like leaves of the laburnum dark and dramatic, especially on the right-hand side.

When all the drawing was completed, I slowly washed over the right-hand side with water, melting and heightening the colours. While the paper was still wet, I restated certain points, such as the leaves and flowers on the top right-hand side, with darker shades, using violet and browns to denote shadows and contrasting the darker parts with the very light beds visible towards the back. I drew in the leaf veins and foreground details with dry pastel- and pencil-work in green and violet.

The tiny stones were created by dropping brown and violet pastel sharpenings into a wet wash of water and allowing them to diffuse.

The shadows cast by the arch and steps were created by taking colour with a soft brush from the tips of the blue and violet pastels. The same method was later also used over a part of the top right-hand side of the composition to create the darker shadows. Finally, I glazed the steps using a warm dry application of burnt-sienna pastel.

*Laburnum pergola.*

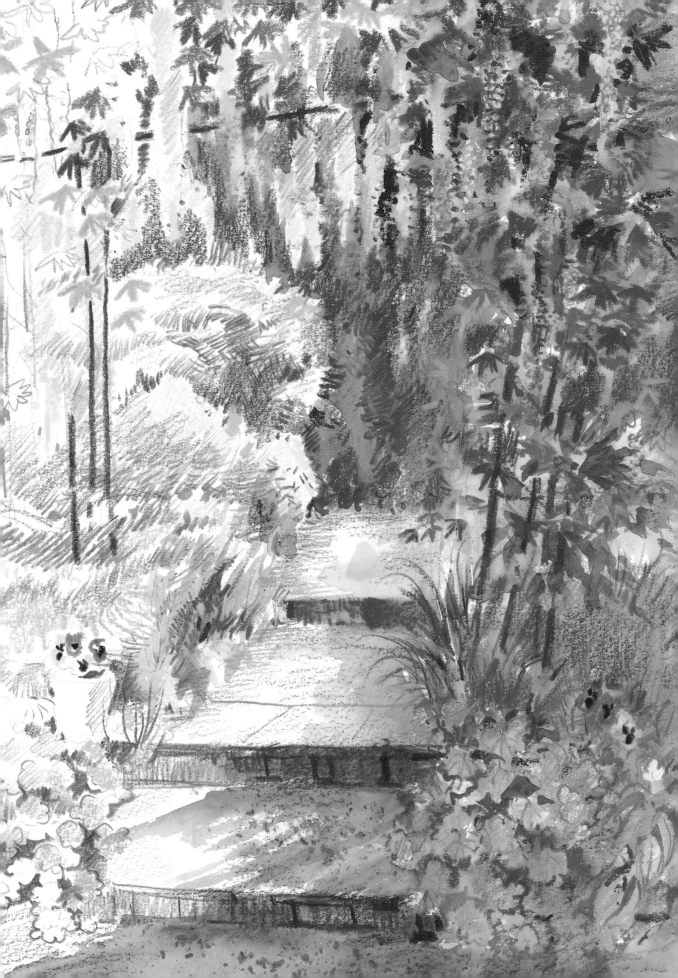

*A combination of colours in short stabbing marks showing an assortment of greens, wet and dry.*

# Mixing greens

Painting foliage and trees could take up a whole book in itself! In my classes, every year, before venturing outside, we always have a basic lesson on the complex mixing of greens, and whatever stage a student seems to have achieved, everyone joins in. It is an endless source of study and a challenge to every artist.

The water-soluble pencils and pastels make perfect companions for outdoor work.

### Colour chart

Here I have set out a simple chart, restricting the mixing of greens to a very easy-to-follow formula.

The first square in each line is in each case a combination of a ready-made green and another colour. Half of the square is then wetted to emphasise the differences when the textural lines are diffused, and the other half of the square shows the interwoven colours left dry.

The second square in each line is a different green mixed with the colour (for example, grey).

(a) Grey plus a mid-toned brightish leaf green = a cool, soft green.

(b) Burnt sienna plus a mid-toned green = a bolder, useful mid-toned green.

(c) A flesh colour combined with a yellowy mid green = a delicate warm green.

(d) Moss green with violet = a 'greyed' darker green.

(e) Red and orange mixed with a mid-toned strong green = a lovely warm autumnal green.

There really is a wonderful variety of greens available. Another good thing you could try is to use the same green throughout the whole exercise.

22

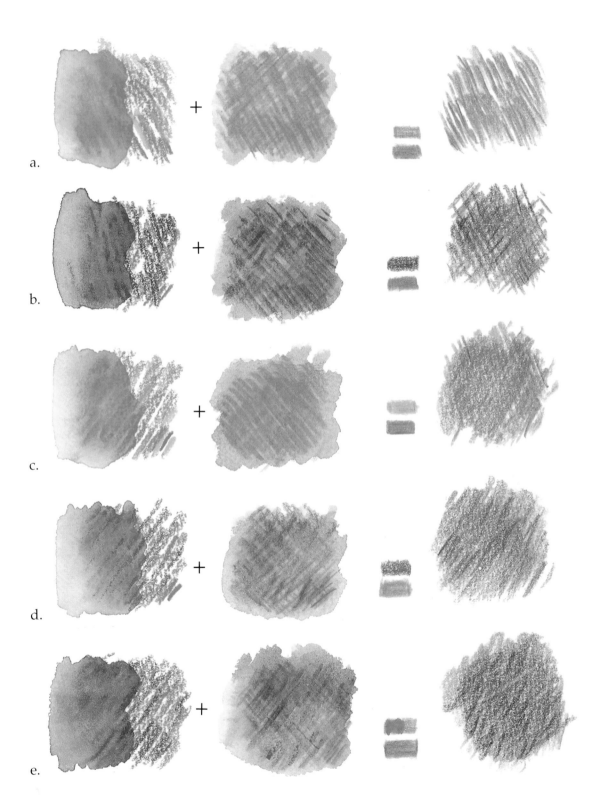

# Trees and foliage

When you are trying to convey the maximum effect of foliage, using line alone in the drawing will not provide sufficient information for the varied details of patterns and textures essential to portray each individual tree or plant. To conjure up the vast and expressive 'artistic vocabulary' needed to paint this subject, I suggest you acquaint yourself with a few of the assortment of leaves in your own garden. Place them on the table and study each one carefully, noting the character of colour, pattern of leaf, and the massed effect of each.

Here I have sorted out several types, using many different colours: blues, greens (both ready-mixed and cross-hatched), violets, yellows, and browns. Although the subject is very complicated, I find that foliage falls into types and can be simplified into distinctive groups: dotty, wavy, feathery, starry, or spiky. By practising these massed effects, an impression of a particular type is quickly produced.

The tree illustration is painted with a mixture of water-based pastels and pencils. I take the first watercolour washes for the tree and foreground from the tip of a dull-green pencil with touches of bright yellow, and pale blue for the distance. The leaves are done in dry pastel, using the sharp edge and sides; the latticework of dark branches is created with wetted pencil; and the cow parsley is blocked in with pastel, with all the tiny details drawn in using wetted and dry pencil.

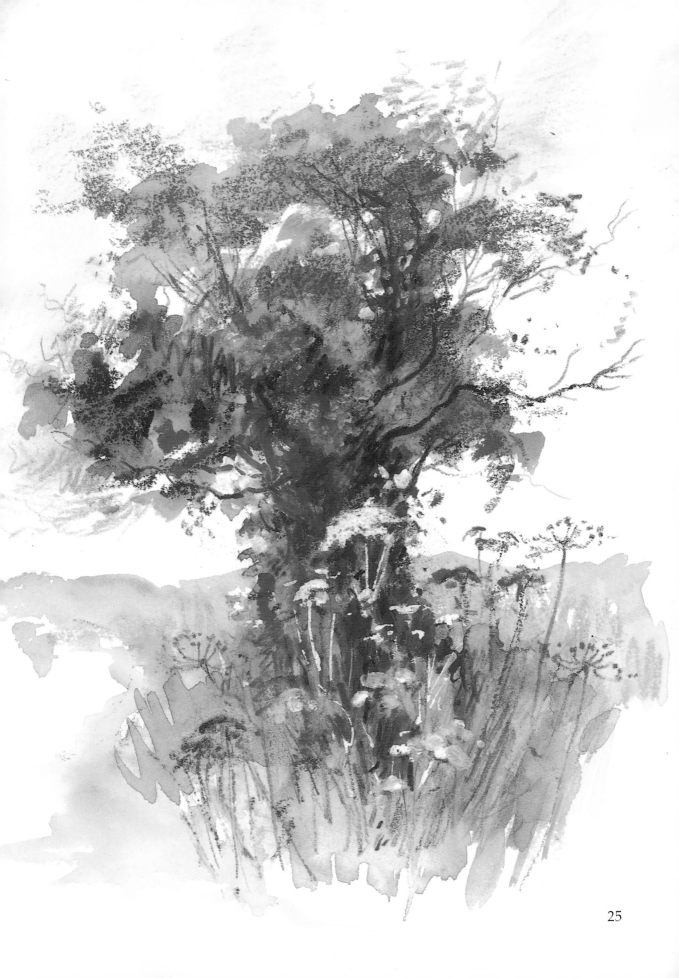

# Using other water-dispersible media

Into this category fall the coloured charcoal and pastel pencils and, in some cases, soft pastels themselves. The chalky fragile surface of both of these offers a delightful run of gentle colour, needing to be coaxed at times from the original colour source of a drawing or a blocked-in area. As you may soon discover, they do not flow as easily as the other water-soluble media, but will disperse in a milky and pleasant manner if this style is required.

Each sort of pencil and pastel can be bought separately, or in prepared boxes of twelve, twenty-four, thirty-six, forty-eight, and, in some cases, sixty or seventy-two. You can also buy a 'landscape' selection, or a collection intended for portraits.

Having selected a few pastel and charcoal pencils, I tried several courses of action. I soon realised that they could be rubbed and smudged, and could be rubbed out, erased, or highlighted with a putty eraser if necessary. They could also be washed over with a soft brush loaded with water. Alternatively, I found I could wash them from the tip with a brush and deposit them on the paper.

In the following exercises I tried out many experiments. First, I used two different-coloured pastel pencils, two different-coloured charcoal pencils, two different sticks of pastels, two pastel pencils cross-hatched over one another, and, finally, two charcoal pencils. I washed the second half over with a brush and water. In the last two examples I used wetted pencils to get a stronger line. Remember that they cannot be rubbed out once they have been wetted.

*Trying out various media.*

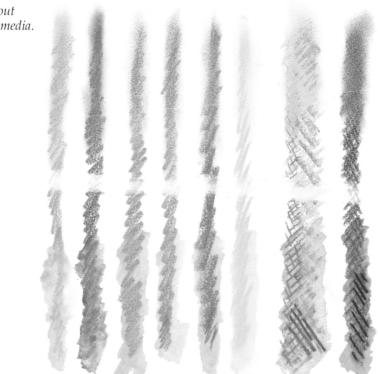

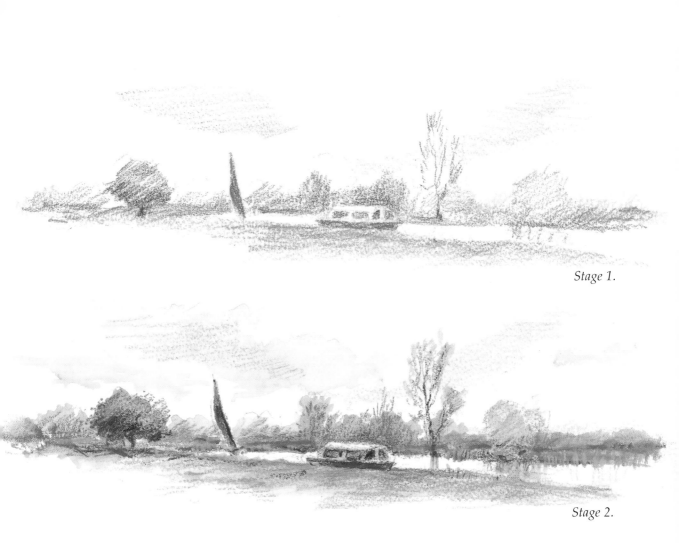

*Stage 1.*

*Stage 2.*

This picture of the Norfolk Broads shows the build-up of the whole scene in a soft covering of pastels and charcoal pencils. I have defined the darker accents with a second and stronger coating of colour. You should take care at this stage not to smudge the picture before you diffuse it with an application of water.

At this stage, I also took colour from the tips of pale-blue and violet pastels for the sky and distance.

When the picture is dry, an additional coating of wetted or dry charcoal or pastel work can be applied, creating extra texture or fuller details. If the final layer is to be dry-pastel or charcoal work, a fixative spray will be needed to protect the surface of the picture.

# Step-by-step paintings

## Cockerel

### Materials

*Water-soluble pencils in the following colours: deep blue, cadmium/crimson reds, ochre, blue, deep charcoal, yellow, brown, pink.*
*Soft No. 6 watercolour brush.*
*190gsm (90lb) Not watercolour paper.*

I photographed this handsome bird while on an art trip to a local farm museum at Hamble Country Park, near Bursledon, Southampton. As so many of my students had such a magical time painting the hens, geese and cockerels of all varieties, I thought you might like to have a go at the cockerel's colourful plumage.

### Stage 1

Here I quickly sketch in the brief details with a deep blue and softly block in layers of red for the comb, dark blue and charcoal for the legs, pink for the feet, and a mixture of yellow and ochre for the neck and beak.

*Stage 1.*

### Stage 2

I add a little background colour with charcoal, brown, and yellow, to give an impression of straw. Using my No. 6 soft brush with clear water, I diffuse the colours.

*Stage 2.*

## Stage 3

While the paper is still wet, I reinforce some of the accents of dark tones of the legs, tail and body, as the wet pastels are at their darkest while fluid.

The feathers need more attention, so I draw more tiny lines of feathers and texture over the body, feet, comb and beak. To complete the picture, I now brush on a wash of light blue from the tip of the pastel, applying it as a glaze over the background and the shadowed area cast in the foreground.

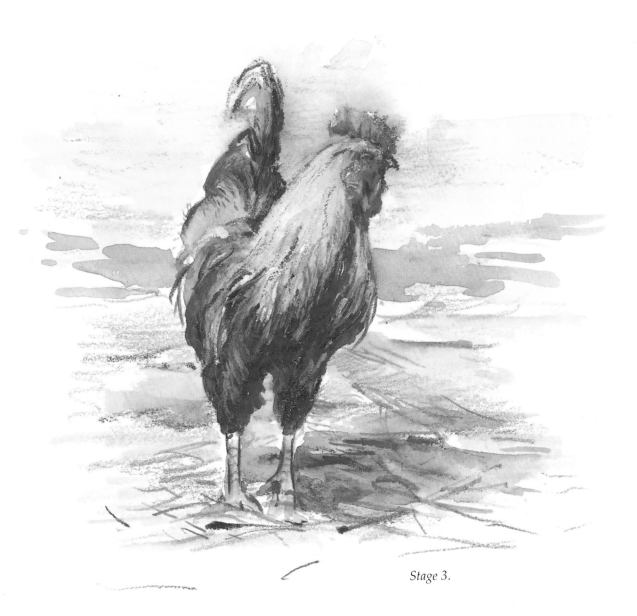

*Stage 3.*

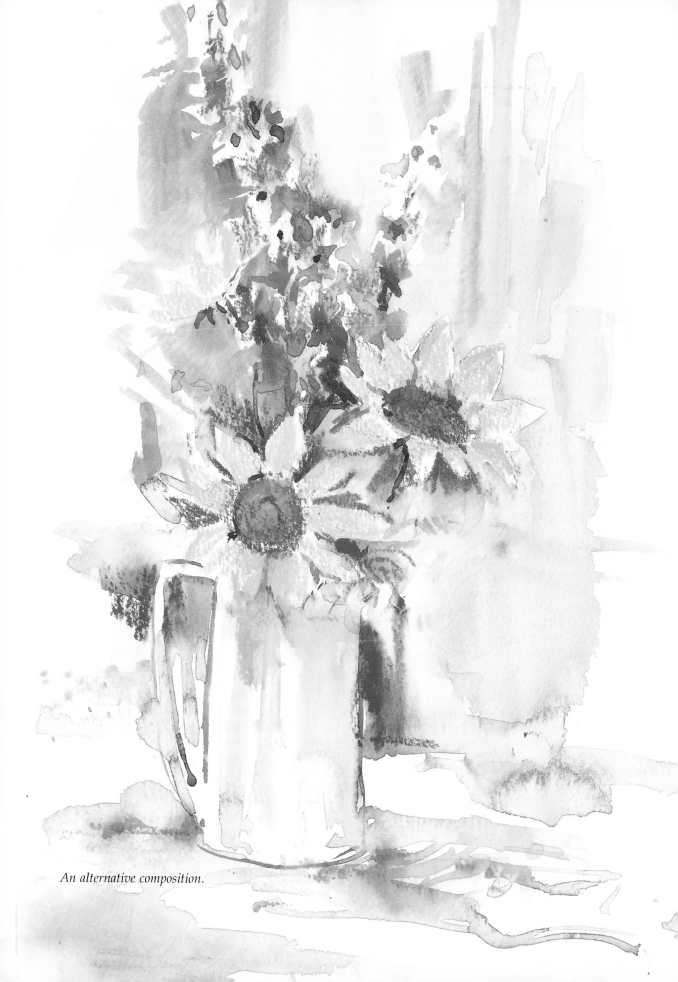

*An alternative composition.*

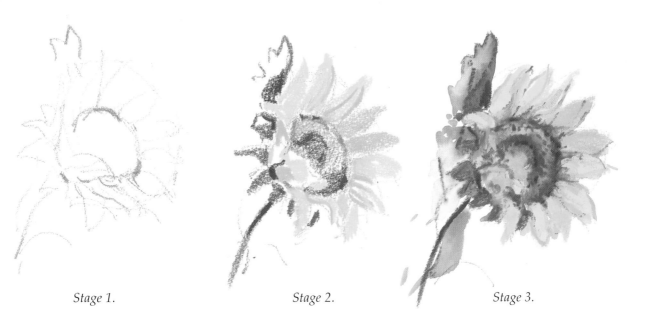

Stage 1.                    Stage 2.                    Stage 3.

# Sunflowers and delphiniums

## Materials

*Water-soluble pastels in the following colours: light blue, mid blue, turquoise blue, dark violet, dark blue, pink, ochre, cadmium yellow, orange, brown, dull green, and mid green.*
*Soft No. 6 brush.*
*Watercolour paper.*

I have used this magnificent artificial-flower study many times during my residential and further-education courses. It has always been a great success, as there cannot be any complaints about the blooms wilting or the gorgeous colour fading away!

I always suggest trying out each specimen roughly before branching into the whole still life. Always try to study how the background influences the foreground. Remember that all the colours and tones of your chosen subject appear as they are because of the current background. Look carefully at the 'glow' and lightness of the flowers. Is the background darker or lighter than the flowers? If the sunflowers, for instance, are very vivid and light, the background must appear quite dark. For a successful picture, you must appreciate the depth of surrounding tones.

## Stage 1

First of all, I place the head in with a simple drawing of ochre.

## Stage 2

Now I block in the flower-centre with ochre and brown applied dry, then add the petals of orange and yellow, also dry, with a series of dull and bright mid greens applied to the left-hand edge.

## Stage 3

I wet the whole head and leaves with a brush, pulling the green 'flowing' colour up into a leaf shape. While it is still wet, I dot in the textured centre, as I need a dark effect, and at the same time I add a few green markings. I use the edges of the ochre and brown pastels, softly, for the delicate petal folds.

Flicks of dry pink and bright yellow are added for extra 'lift'.

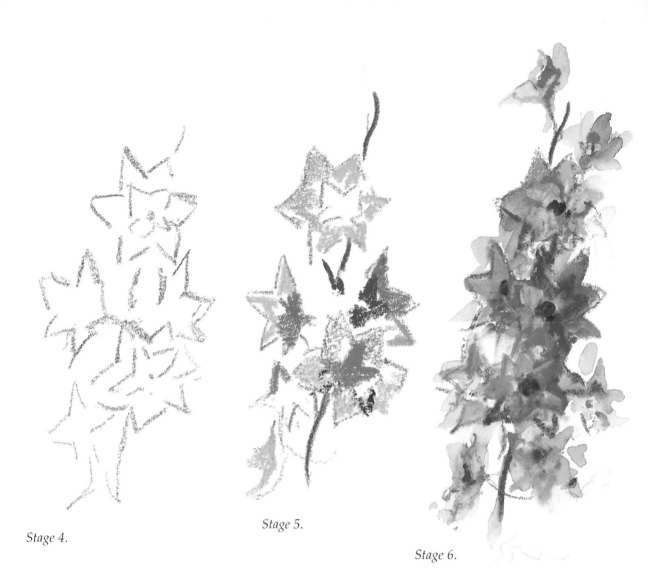

*Stage 4.*

*Stage 5.*

*Stage 6.*

The spangled star-shapes of the delphiniums are a delight to paint.

### Stage 4

I sketch in the main shapes using blue pastel.

### Stage 5

In the next stage I use pink and the range of blues and violets to draw clustered star motifs, then connect them with a strong green trailing stem. It is vital to use 'clashing' colours to achieve the variety of colour mixes essential for the next step.

### Stage 6

I now add clear water and the flowers blend beautifully into a pyramid of hazy blue and violet stars. Alternatively, several of my students have tried using a spray at this point, and have had some excellent results. These flowers now need the addition of fuller details of their petals, edges and centres. Using the sharper edge of the dry pastel, I neatly draw in the many edges with contrasting colours and deepen the centre with a dot of dark blue.

### Stage 7 – the finished painting

Finally, I put in some light drawing around the whole picture, outlining some features and strengthening the foliage, and concentrating some colour and tones in the background.

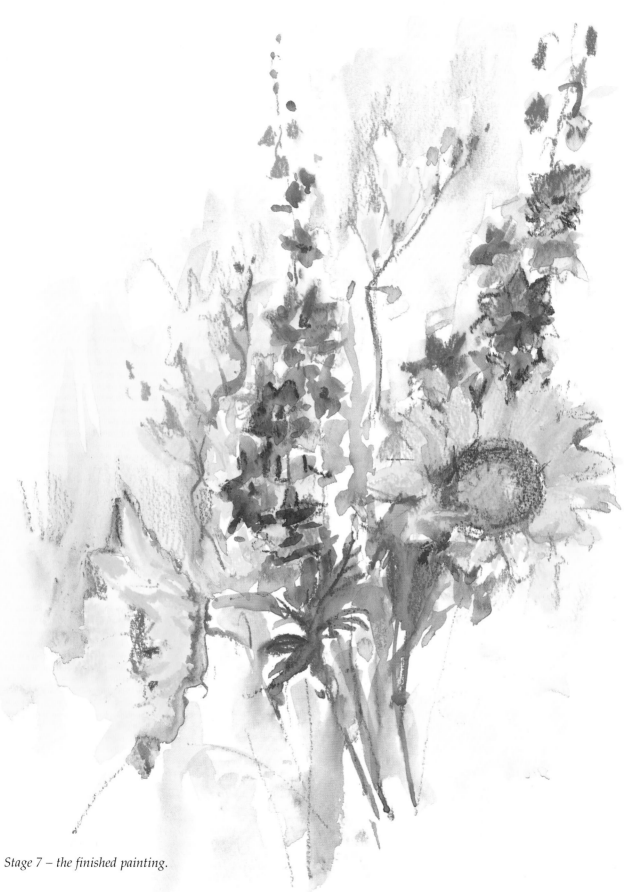

*Stage 7 – the finished painting.*

33

# Seaside reflections

## Materials

*Water-soluble pencils in the following colours: ultramarine blue, burnt sienna, raw umber, orange, brown, mid violet, and dull mid green.*
*No. 6 watercolour brush.*
*Masking fluid and ruling pen.*
*Watercolour paper.*

This small seaside cameo is of my son Richard, many years ago. He is now twenty-four years old! I used a coloured photograph, which helped with the tones and important features such as the reflections. Do bear in mind that coloured photographs can be deceptive, so colour notes should be made at the same time if a special colour theme is to be remembered!

## Stage 1

First I pencil in the child and seaside setting, using my raw-umber pencil, then draw over the highlighted areas with the masking fluid, over his back and head, and over the small rocks and ripples in the pool.

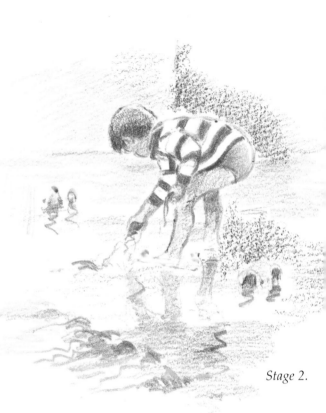

*Stage 2.*

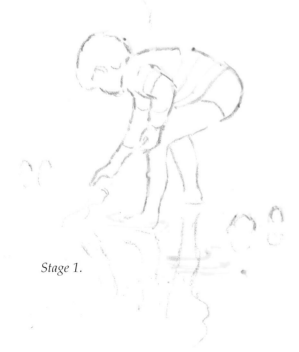

*Stage 1.*

## Stage 2

I loosely scribble in the background colours, using violet and dull green for the rocks and seaweedy pools, pressing heavily in order to deposit more colour, as these features are in the foreground. Raw umber, blue, and orange are blocked into the foreground pools and the impression of the reflection. I spend longer on the figure of the child, outlining the blue details on his garments, and filling in the flesh tones and hair with burnt sienna and raw umber, then taking down some of these colours into the reflections. Be careful not to lift the masking fluid underneath!

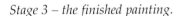

*Stage 3 – the finished painting.*

## Stage 3 – the finished painting

In this last stage, I add water over the whole picture with the brush, except in the area of light water on the left-hand side, to spread and dissolve the watercolour. Here and there I restate darker accents, using blue and brown straight into the wet wash, as in the rocks and reflections, details of the shadows on the legs, and folds in the clothing. After the picture has dried, I rub off the masking fluid and soften the white markings with pale blue painted from the tip of the pencil, applied with the brush.

To gain maximum effect from the colours, I glaze over the water with scribblings of blue and brown to give movement to the pool and draw in more rock textures in the foreground. Sharp and trailing lines in dry-pencil lines are added, indicating the varying contours of the seaside pools.

# Apple on a cushion

## Materials

*Water-soluble pastels in crimson, burnt sienna, pale violet, moss green, yellow, mid blue and raw umber.*
*Soft No. 6 watercolour brush.*
*Watercolour paper 190gsm (90lb) Not surface.*

Here I wanted to capture the contrast of these two things: the flowered cotton material, with its rich red and yellow splashes of colour, and the large shiny red apple. This composition came along by accident! During an art class, the still life of red apples got knocked over and rolled along the floor. While we were gathering everything up again, I placed one of the fruit on this cushion to stop it running away again! It looked rather cheeky perched there – so I thought I would paint it.

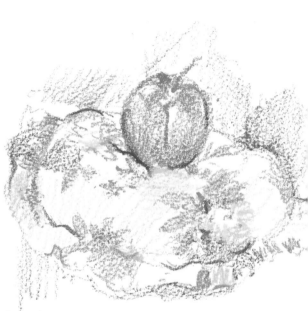

*Stage 1.*

## Stage 1

Working with a blue pastel pencil, I draw in this still life accurately, making sure that the apple looks as though it is snuggled into the soft surface of the cushion. The apple is sketched in with crimson and raw umber; the background with blocks of blue, burnt sienna, and red; and the cushion with star shapes of green, yellow, blue and raw umber, keeping the drawing loose and open-weaved.

## Stage 2

Using the soft brush dipped into water, I begin to wash over the dry drawing, blending and heightening the colours. I then outline some of the cushion with a blue and violet dry line to highlight the dent in the centre. I leave some of the white paper untouched in preparation for the shine needed in the last stage.

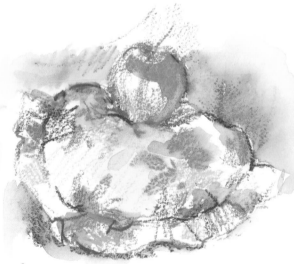

*Stage 2.*

## Stage 3 – the finished painting

After the painting has dried, I reapply and intensify some of the background colour, using the soft brush and taking the colour from the burnt-sienna pastel. I complete the apple by adding a mixture of more red and violet and applying a wash of yellow as reflected colour from the cushion, and I leave a tiny white patch for the shine on the apple's surface. Finally, I draw some little dots of colour, using the pastels wet and dry, into the pattern of the cushion, and also some additional folds in its decoration, using more outlines in red and violet.

*Stage 3 – the finished painting.*

# Gallery of finished paintings

## Rose arch

I used this cottage rose-arch, which is actually in my own garden, when I made a 'mixed media' video.

I painted the whole picture with water-based pastels, using burnt sienna; bright, dull and emerald greens; yellow; pink; crimson; grey; violet; and ultramarine and cerulean blues.

This complicated study was carefully drawn in with blue pastel. I tried to simplify all the mass of flowers and foliage by blocking in the background in a band of dull green dotted with dark blue, leaving another ribbon of yellow for the highlighting. The stone steps were washed in with grey and violet, and while the paper was still wet, I drew in all the little stone details.

The dramatic arch of burnt sienna, with shadows of violet, needed to be in contrast to the sunlight behind. This area was lifted by using neat stabs of darker greens for the shaded foliage, and yellows and pale greens for the background.

The assorted pots were painted in using greys and sienna, with details added in dry and wetted pastel.

Finally, the flowers and foliage were especially chosen to complement each other in shape and colour.

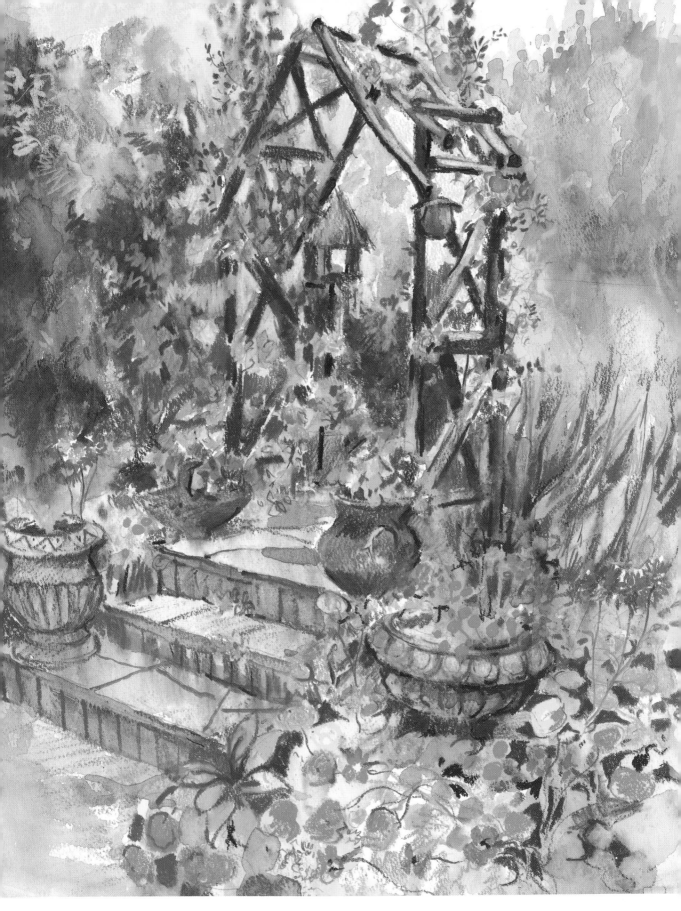

# Still life

The theme for this picture, which I carried out mainly in water-soluble pastel, with details done in pencils, is a container full of shiny green apples, onions, cherries and strawberries, spilling out on to a background of a flowered cloth. This has proved to be an absorbing and popular theme in my art classes.

This illustrates well the combination of pastels and pencils, and suggests how each comes into its own when used side by side, as shown in the watery washes from the thicker pastels for the fruit, and the hatching and interwoven lines from a defined pencil style, as shown in the cloth patterning.

For this picture I chose gentle colours such as violet, pinks, yellow, mid green and cool greens, crimson, and vermilion. I used pastels to paint in all the underwashes, including the shadows, the folds, and the container.

Although I attempted to enliven the colouring using the pastels, I preferred the response of the pencils to the negative shapes and the details of the pips, stalks, and accents on the flowers to denote intricate modelling and decoration. The only dry-pastel details were those I added to the lines on the onions and the outlining of the green apples.

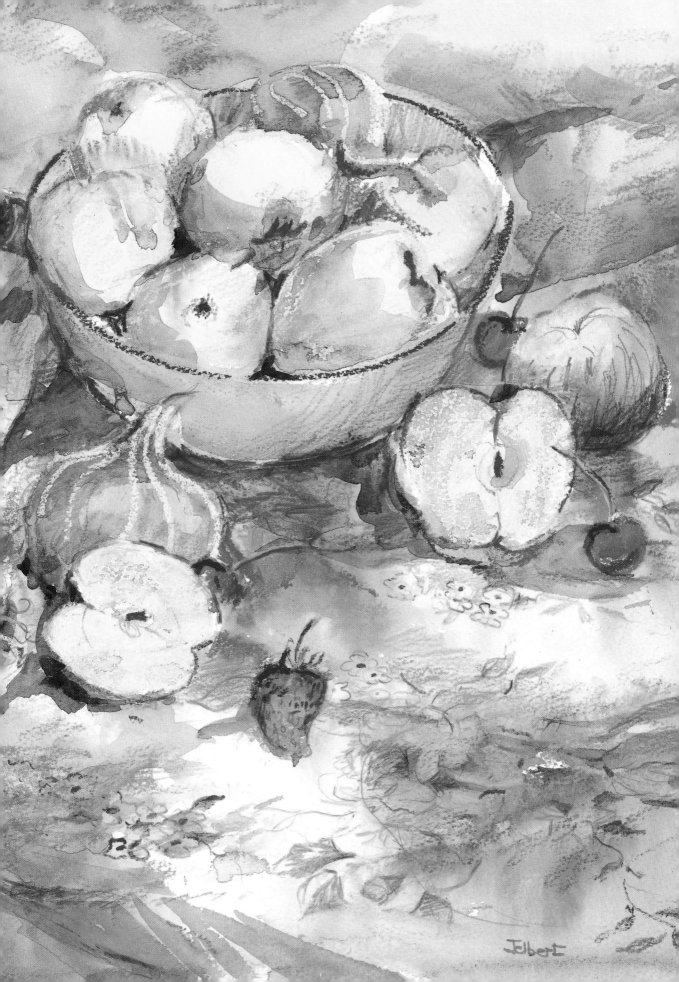

# Daffodils

There is nothing more refreshing and pleasing than gathering a bunch of crisp, delicately perfumed daffodils. Their bright, cheerful trumpets announce the return of spring, and I always feel that they resemble banners of hope for the year ahead after the dark, cold winter days.

Every spring term my art class asks to be allowed to paint daffodils, and it seems as if this habit is here to stay! There are always the same pitfalls, though: nature rarely supplies the perfect composition, so we have to compose it carefully for ourselves.

This bunch of daffodils was arranged so that their heads are at varying angles...three-quarter views, side on, backwards, and full frontal, so the whole vaseful looks three-dimensional and natural. Always add some leaves in the vase and perhaps some leaves, a petal or two, or a bloom lying on its side to break up a bare foreground.

I used water-soluble pencils and pastels in blues, burnt sienna, violet, bright and dark greens, orange, and browns. Several yellows, including cold ones and warm ones, plus yellow ochre and burnt sienna, were drawn in for the flower heads. I wet them for a freer wash and tightened them up with the details in violet and brown after the wash had dried.

Before starting on any subject, remember to make sure that you understand the influence of the background. The flowers are the colour and tone they are because of the background colour and tone. See how the dark accents behind the flower-heads highlight them and make their colour sing because of the colours chosen. The contrast of the light heads against a darker background (in the centre) and the darker ones against a lighter rendering (on the right) is an important thing to build into any flower picture to prevent the picture from being too much the same all over.

Note, too, that the glass container has areas of contrast, with the light rim and background, and the darker background which highlights the varying lines of light playing on the glass. The clear, sharp lines drawn by the pencils are ideal for this detail.

I have outlined several of the petals with the pencil and then washed over with bright yellow to 'bloom' the colour into the surrounding area in order to add interest.

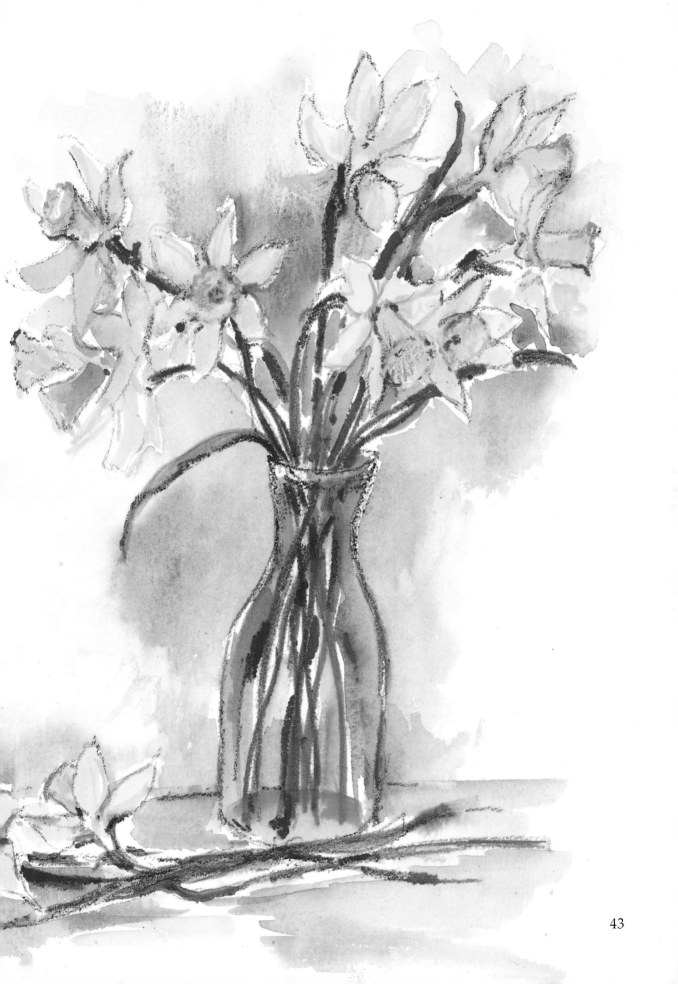

# The French balcony

This is a very detailed work using cerulean and ultramarine blues; vermilion; dark and light green cross-hatched with violet; yellows; and burnt sienna, in order to gain all the variety of greens needed in this picture. The pencil-work is mostly dry, giving an open-weave effect and letting the lightness of the paper show through the delicate pencil lines.

The foliage needed to be drawn in using many different markings, to make the plants varied and fascinating, as with the vines, fuchsias, and distant bushes. When some of these darks needed intensifying, I dipped the pencil into water (or my mouth!) and applied several layers of neat

colour until I had the colour and strength required.

The shadows are gently drawn in with slanting markings close together, using violet, burnt sienna and blues, and making certain that they fall correctly along the ground, across the walls and along the steps. Note how the background made the foreground subjects 'glow' with the sunshine, or become darker and more intense with the deep shadows. It was this interplay of contrasting elements – the distance influencing the foreground subjects and the shapes of the long shadows across the balcony – that attracted me to this complicated but intimate scene.

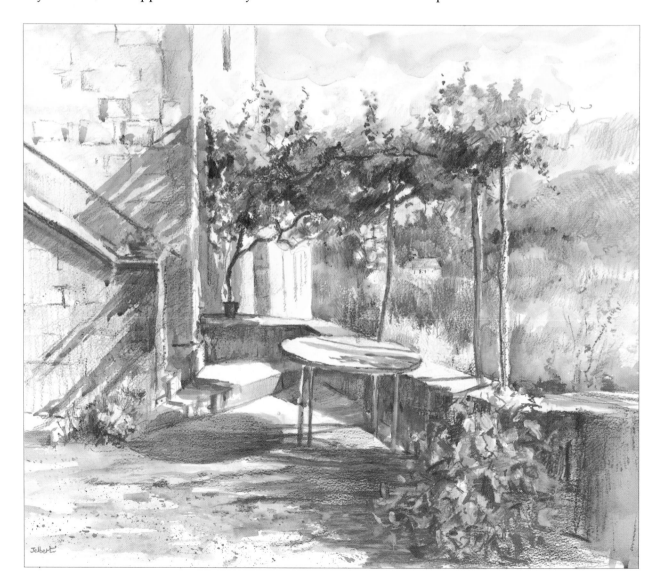

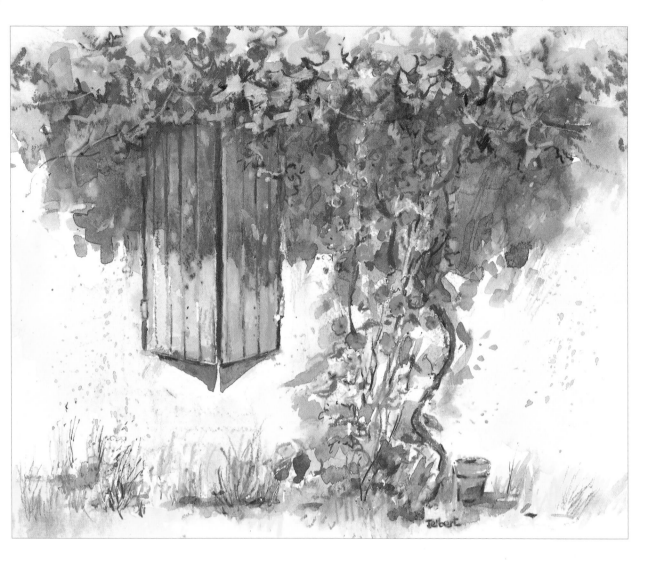

# The blue shutters

In this French scene I used water-soluble pastels and pencils *in situ*. The separate stages are hard to define, and the picture was done very quickly in the hot sunshine! Everything seemed blue, and the colours of the shadows and the shutters went so well with the soft tissue-pink of the hollyhocks.

I drew in the preliminary details in blue pencil, and then overdrew, in dry pastel, the canopy of vines, flowers and foliage at the base of the vine. I blocked in the deeply shadowed area beneath the foliage, beneath the shutters and around the plants, then briskly established the wall colour of Naples yellow. To this, I added small shavings from the blue pencil to add texture, and a ground covering of bright green with specks of blue and violet, using a wash taken from the tips of my pencils.

Next I wet the whole space and outlined the highlighted areas with dark greens and blues; then I crudely hatched some ochres and pinks into the shadows. Finally, I used a steel-nibbed pen to define some of the branches and the details of the grass.

45

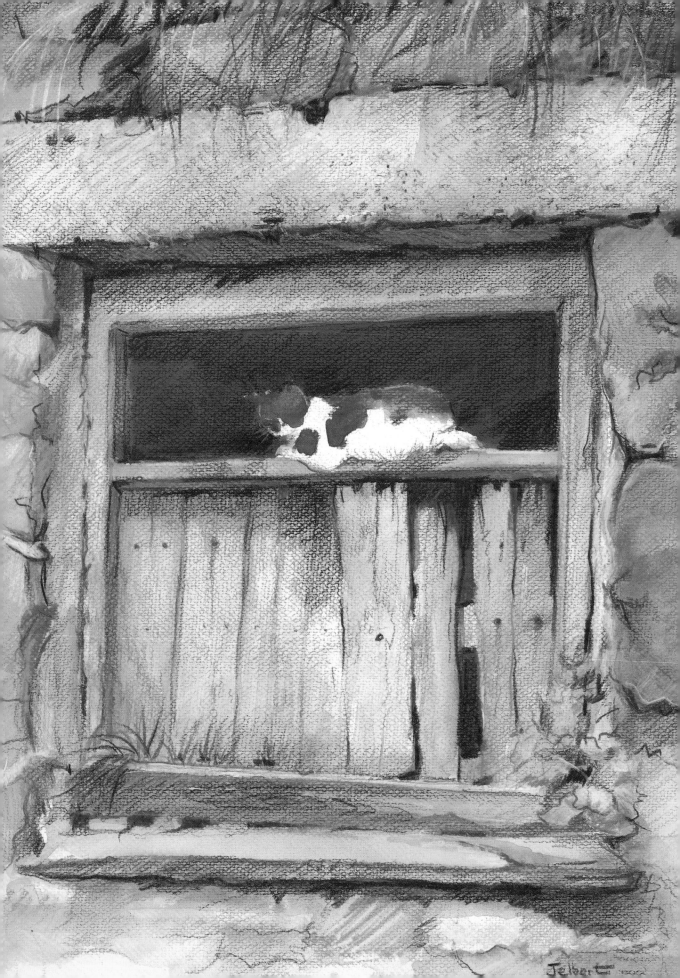

Jelbert

## Farm cat in old barn window

I discovered this delightful scene in an old Cornish farmyard that had been painted long ago by the Newlyn artist Stanhope Forbes. It resembled a splendid time capsule containing a multitude of wonderful 'olde-worlde' farm scenes of geese, old barns, crumbling farm windows and doors, and ancient farm machinery half hidden in weeds and cobwebs.

This window really did have this cat sleepily watching me in the peeling blue frame. The dark, shadowy background contrasted beautifully with the broken wooden boards punctured with rusty nails, and the animal's light markings.

Over the whole surface of a canvas-marked watercolour paper I washed over a covering of yellow ochre, using a brush and taking the colour from the wetted tip of my water-soluble pencil, and then let this dry. I then drew in an initial sketch of the window and cat details, the layout of the blocks of granite, and the weeds sprouting from the surrounding window frame.

I cross-hatched raw- and burnt-sienna pencil-work over some of the walls to give a weathered effect and wet some of these for softness and contrast. In the variety of foliage I used a bright light green and drew in the dark shapes with wetted mid- and dark-green pencils for maximum depth.

For the shadows, I used dry dark-blue and brown pencils and sketched in the dark areas, allowing the warmth from the yellow-ochre initial wash to glow through.

I added the cat's markings with a small rigger brush and a wash from a mixture of black and brown pencils. Finally, I carefully drew in the details on the wooden planks, the grasses, and the rust stains, using dry mid-brown and light-red pencils.

# Conclusion

I have found that these astonishingly versatile media, which you can use for painting, drawing, sketching and for producing finished work, whether as mixed media or in their own right, have fascinating and unlimited possibilities.

I believe we are at the beginning of a new era in using these water-soluble media ... a sort of renaissance in using new media. They have been regarded as a second-rate form or as one for use only by children for too long! As I hope you have discovered, they can be dramatic, fragile, watery or dry, and all these in the same picture if required. There are no set rules!

In the time I have been demonstrating to art groups, the use of water-soluble media has increased dramatically, as more and more people come to appreciate the freedom and flexibility they offer.

Using these marvellous modern media means an exciting future: remember that there is no such thing as retirement for us artists! With all these possibilities, there is no excuse for doing dull work, so I wish you many hours of enjoyment and successful results!

# Be creative with **Search Press**